An image – dairy

from the Balkans.

by ROLAND PENROSE

July – September 1938.

for Lee

Athens
Mikonos
Delos
Syros
Mycenae
Corinth
Nauplia
Epidaurus
Kalkis
Haghia Anna
Delphi
Hosios Loukas
Lamia
Thermopylae
Meteora
Larissa
Salonika
Kavala
Thassos

Sofia

Bucarest

Tismana

Tirgu-Jiu

Roncu

Sibiu

Brașov

Bran

Turtucaia

Brebu

Balcic

Silistra

Fougarash

The ROAD

is

WIDER

than

LONG.

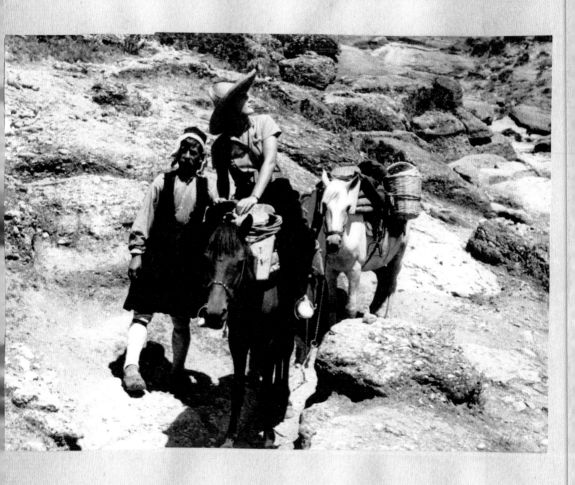

THE ROAD IS WIDER THAN LONG

They breathe with the night in houses
whose marble veins are washed with
sail cloth

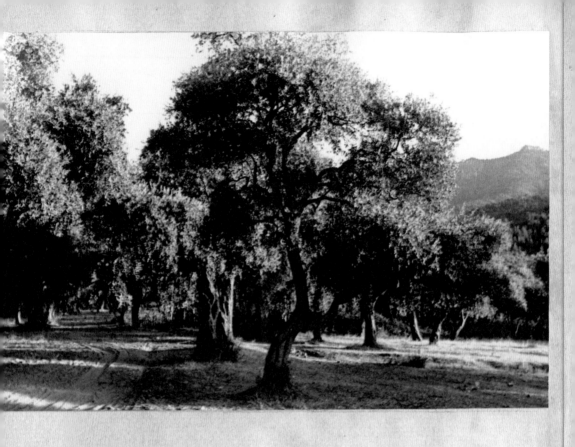

whose carpets are covered with olives

whose gardens begin under the sea

they breathe with the night

enemy the SUN closes their eyes

the day of summer lasts

until the earthquake hatches

from the dream of heat

the dream of cold

Let us through
lift your four striped arms
and let us through
we need dancing, young grass,
children to sing for rain

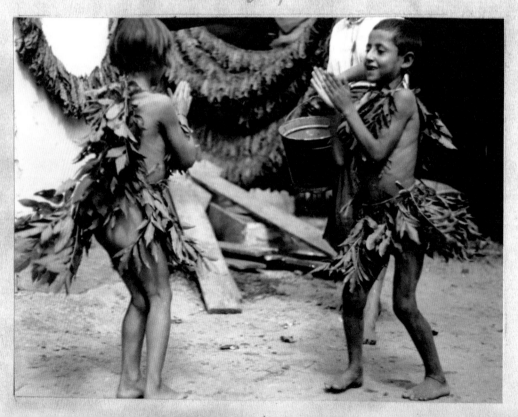

Ask have we got time

we want more than they are

willing to allow

their wasp helmets

their guns pointing

to the ticket office

have we got time

have we got papers

have we got money

have we got ice.

Dragomir Stanescu wants to see you; he has got the ice with eggs painted on it made specially by the peasants. But he knows that we shall not need it nor anything else. It will be dark We shall not know which is the inn and which the church — that's the prison for the fascists, that the graveyard for the communists— No politics here

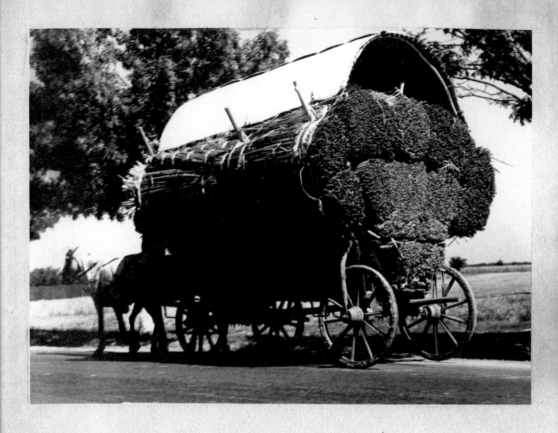

The cart that blocks the road has been
at work for six hundred years,
standing to their necks in water
the men cut reeds, leeches eat
their bones, their throats are too

9

dry to sing, they have not
earned six days leisure, six
days to sing "auf tzac"
and the road is blocked.

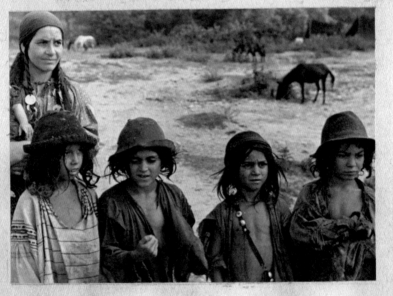

In the river a gipsy washes the
inflated bellies of her children,
bellies full of wood pulp, yelling
and government regulations —

The Nomads may not move their
Tents. The Markets are closed to them
The Prefect has no time to waste
Though I am obliged to listen to

you I am not obliged to give you
satisfaction — Do not disturb me
let me get on with my Work.

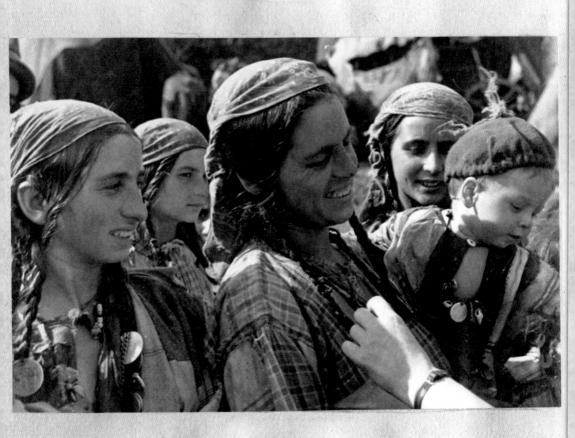

She tore her dress

a dress covered with a dress

and covered with a dress

she tore her dress to mend it

joined by her fingers

torn by her breasts

her dress tears from within.

well

STONE

GROUNDS

the

The road is wider than long
trees are thicker than tall
wells reach to the clouds
their blood is more solid than their bones

they have filtered it churned it kneaded it
refined it driven over it in the open fields

thrown it to the wind beaten it with
flails
ground it dried it baked it in kilns

Their Blood

the **LION** *coloured forms of antiquity*

stands in groups round the church
dressed in veils and embroidered coats.

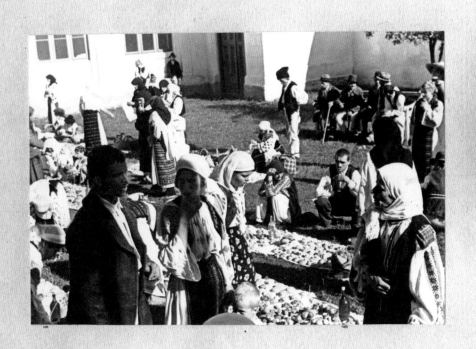

waiting endlessly
for a candle to be put out by the rain

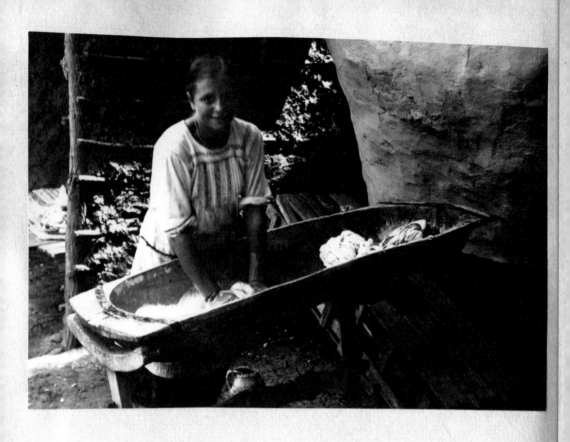

they who have time have no time
it is the same today as last Friday
as the day we stole the corn
as the day she washed her hair
and it rained from the blue

HAVE YOU SEEN the woman
age 100 asleep on the sledge
the man who lost a leg in America
and an arm at Bran

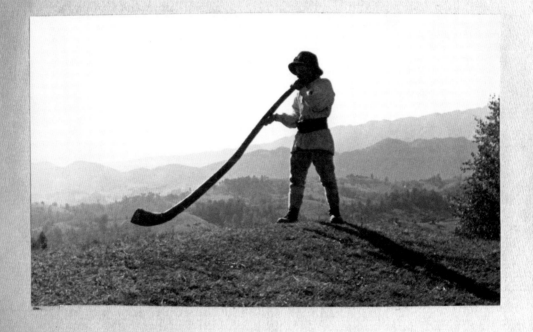

the blind man with 3 eyes
the dwarf who can play the flute
with his foot

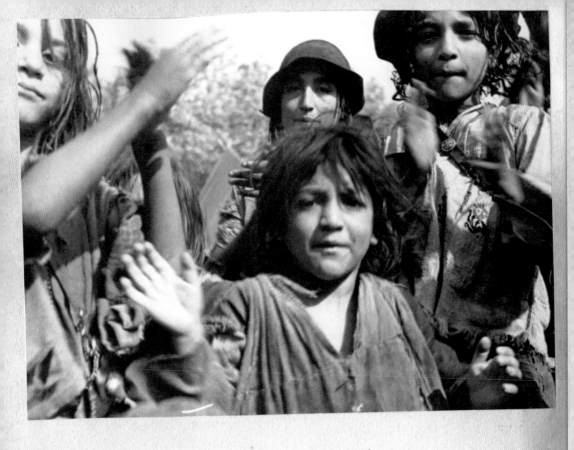

they can all sing

every jack man

and the little girl
whose breasts begin to break the plain

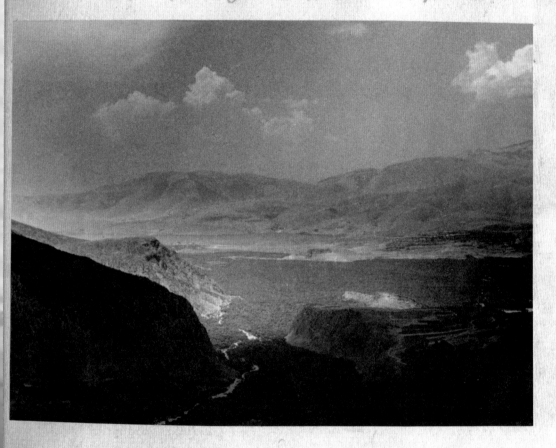

whose sisters lie clothed in crops
their valleys fertile

their springs sacred

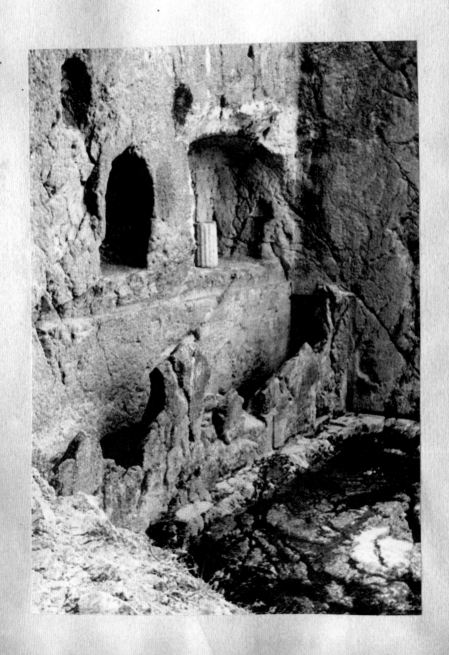

Vapours escape from the rocks

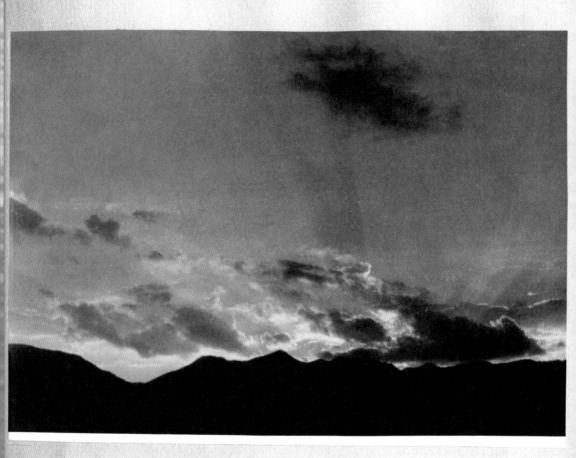

writing tomorrow's news in the sky

we have forgotten yesterday
and tomorrow's news is bad news
our children need medical attention
we need a house without walls
surrounded by fire
the doors open to all who can see
our road is wider than long.

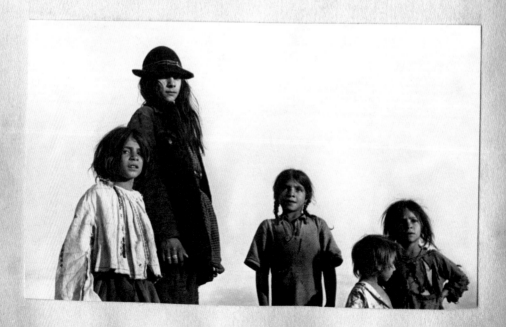

She cut her finger while making a salad
nobody could understand

the trees wore white aprons and played sea music
at night their black leaves
shaded the sky from the glare of the lamps
they didn't understand a word
but they laughed

The olives the thistles the dust
boil together in their sleep
there is one white sheep in a black flock
there are donkeys shepherds goats
old dust a new car and a bridge

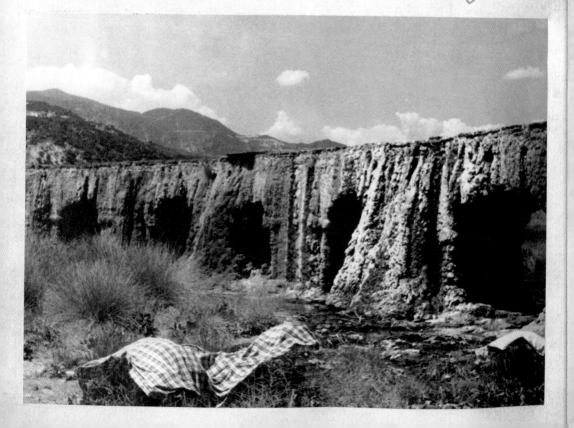

daily we make love under that bridge
but we don't understand a word.
At the end of the road shiploads of light
are sucked down between stone walls

into a new sea.

At Kalkis everybody is in the streets
there is no room in the streets
there is no room in the houses
they have come for the earthquake
and they don't understand

they smile

they send a pair of eyes with ice and fruit

the little girls talk endlessly

holding hands across the road

they clutch at my fingers

there are sixteen children

swinging on my eyelids

They showed us the way to a beach

with flying fish

and laughed.

At Delphi the cliff

translated her voice.

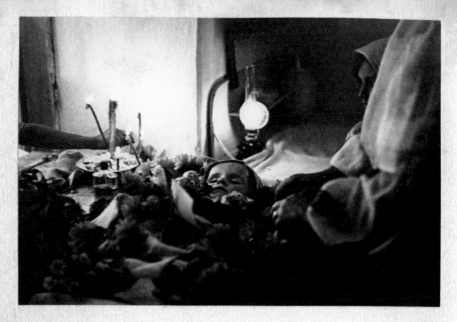

How imprudent of you to have died

Oh how we miss you

when your father comes home

you will not be there to hold his bicycle

why have you not kissed me for three days

why don't you smile oh darling

oh how we miss you

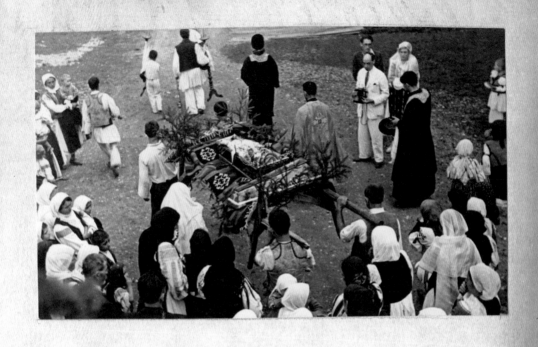

You are going on a long journey

you will meet three hunters at a gate

they will show you the way to your new home

Oh my darling how we miss you

how unkind of you to die

but should you try to come back

you will suffer more than us

the ropes that bind you are strong

the horse will lead us to your grave

the tree that dies with you

will be torn down

your heart will be filled with knives.

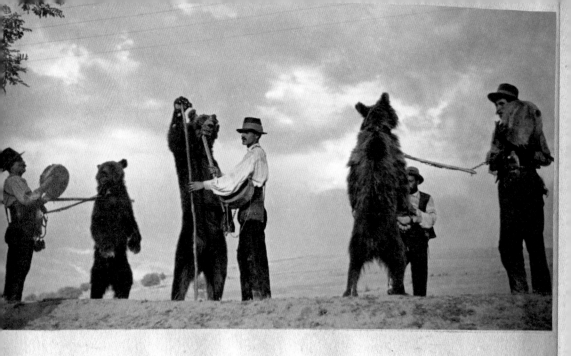

The macedonian whose flute was made
to kill stands everywhere
his bears will dance for you
they forget the dust for a little music
the macedonian will be able to buy
a pair of gold eyes for his bride

That will be after the rain, after the storm
which makes of the mountains a lake
blinding with red hail

mixing earth fire water and air
in the same pot, hitting across the steppe
the naked peasant on both cheeks

Until then nothing can be done

we can only talk in whispers in the hotel
the town is sick but noone dare say so.
Maritza up behind the North Station
could cure it her green leaves
and the strength of her pigeon voice
heal where other music wounds
each note wounds the last heals
the porters the suburban peasant
the policeman and the minister's wife
all go to her she gave power

to the last dictator and then killed
him with a needle, the gold magnate
whose image is already painted
among the saints will also die suddenly
Maritza is strong
the porter puts his son
into the belly of her guitar
her understanding is his security.

Every evening the shops burn
white blocks in bandages receive their guests
a rich organisation fetches visitors from the
cellars and spreads them out in groups
tomorrow they will be driven to the next city
They see the town the town sees them
They like it.

Lovers who escape, who are free to separate
free to re-unite leave their tongues
plaited together hidden in the dry grass
folded in peasant made cloth
embalmed in the green memories of desire

She must tie her hair
round the branches

LEAVE YOUR TONGUE
STUCK
to the bark

This will avoid all danger
of not meeting next year

Then the journeys alone that fill

the world become fertile

in each tower on each headland

as the frontier is passed lovers

watching for the red train

have grown into each other's eyes

the colour of their hope is

the white feather of a volcano the blue eye

which opens in the clouds before sunset

the stage of a greek theatre echoing

the smile that drops from her lips

like bats they make love by day
their heads buried in the stones
their feet searching for lions in the hills

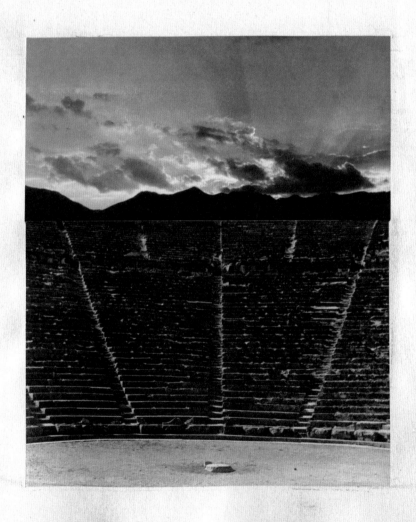

At night we found a deserted city

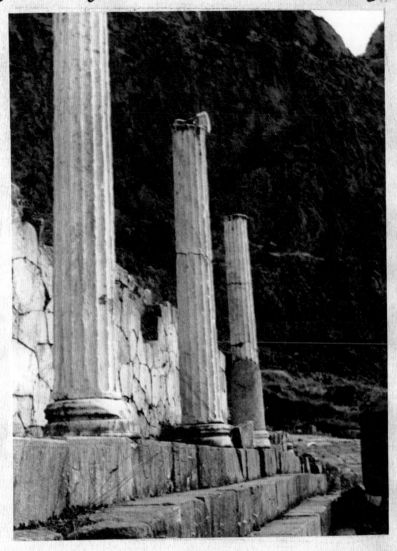

water ran under the streets

the houses dry and full of herbs

formed the labyrinth of a dead shell
a boy inside the column in the market
was still alive another 500 years
will be sufficient to deliver him
the Americans are the first in the field
with an offer of clothes and a scholarship
We climb and bleed with the thistles
our fingers feel into the tomb of the saint

IF YOU ARE LYEING YOUR FINGER WILL BE
TRAPPED
IF YOU TELL THE TRUTH IT WILL LEAD
YOU OUT TO THE OTHER SIDE

to an island

Where they dance in the hangman's bedroom

where the guns are used as saxophones

and the powder magazine is to let for love

In the rocks are pools where the sturgeon

can take 40 passengers a time to visit

the wreck of a Turkish battleship

Tea is served on board and the fish

have become so tame that they are

willing to show visitors over their

genital organs.

Each rock that floats above is

crowned by a monastery and

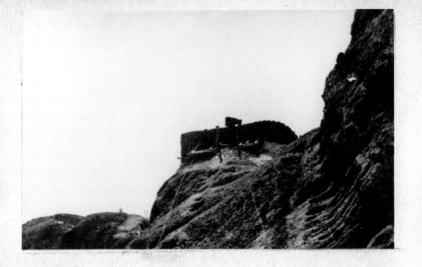

the monks can lift a man from

water as deep as the eye of a goat

to their dry gardens where a drunken

pope his face consumed by frost

sits alone with religion.

But they are working day and night

the new military road is approaching

the rubber seated pilgrims will come

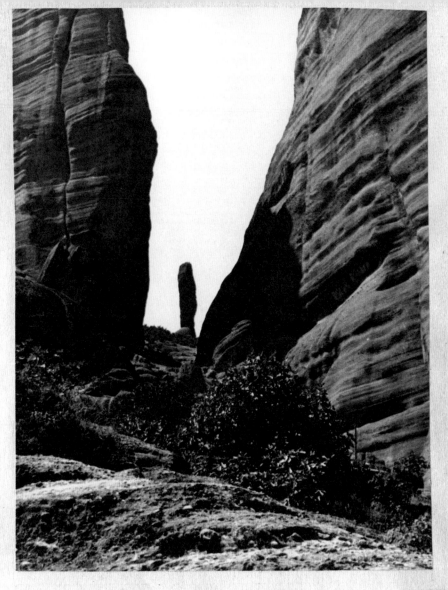

to a world of music blown across
drained swamps and mountains
caught in a net. Magic lives in this rock

These stones have seen seventeen battles
the Assyrians the Turks and the Australians
landed here these crops grow in human blood
they are the finest in Europe the
public gardens have the tallest fountains
of any city since Thebes.

THE
BAND
CONCERT
WILL

BEGIN

NOW

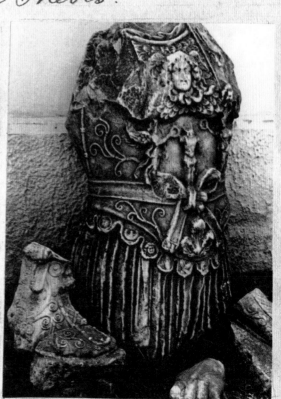

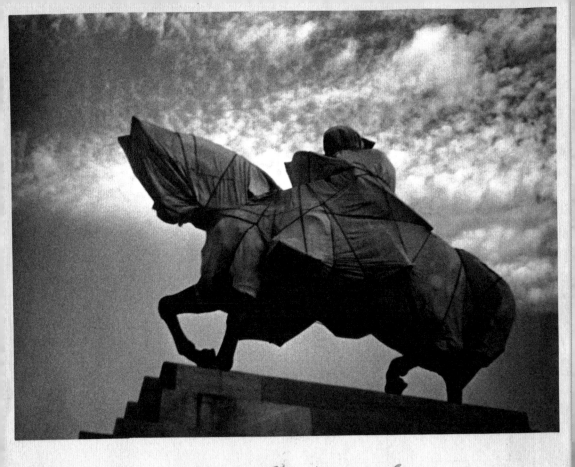

The cock pit the bull ring the open air
cinema the dance hall the committee
room and black exchange are at work
turning their blood shot music while
Maritza tunes the two cords of her guitar

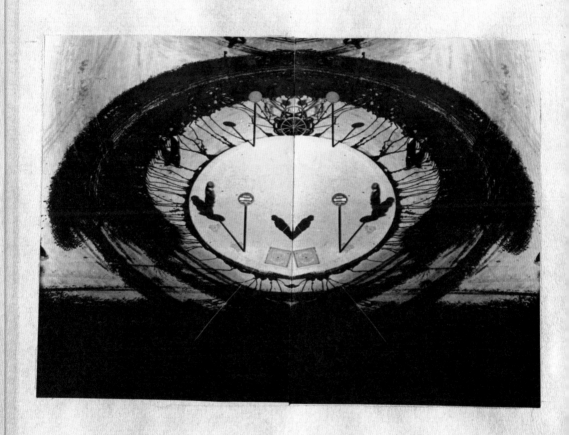